THIS NOTEBOOK BELONGS	то